WORLD PRESS PHOTO 1994

Thames and Hudson

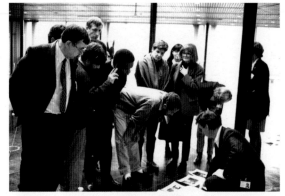

The jury at work. During an action-packed week in February, the nine-member jury fulfilled its tightly scheduled task on the top floor of KLM's Head Office just outside Amsterdam.
Photos: Ronald Roozen/
World Press Photo

INTRODUCTION

The World Press Photo Foundation is an independent platform for international press photography, founded in 1955. This platform manifests itself in the annual World Press Photo of the Year Contest and the corresponding yearbook and exhibition.

An independent international jury consisting of nine members judges the thousands of entries submitted by photojournalists, agencies, newspapers and magazines from all corners of the world. Since 1983 there has also been a children's jury, which separately selects the Children's Press Photo of the Year.

World Press Photo publishes this yearbook in conjunction with the annual exhibition. On the one hand the book serves as a catalogue, including all prizewinning submissions of the year in question. On the other hand it is a self-contained document, reflecting the best in the press photography of a particular year. The exhibition is shown all over the world, subject to the condition that all prizewinning entries are exhibited at every venue without any form of censorship.

World Press Photo aims to increase public interest in press photography and to promote the free flow of information worldwide. It also stimulates discussion about aspects of photojournalism among those who are professionally involved in it. This takes the form of initiating and organizing seminars and debates in different countries. The first World Press Photo Masterclass will be held in 1994.

World Press Photo operates from Amsterdam, the Netherlands. The foundation is a nonprofit organization, whose activities are made financially possible by the proceeds from the annual exhibition, royalties from the yearbook and sponsorship by Canon, Eastman Kodak Company and KLM Royal Dutch Airlines. The foundation also receives a subsidy from the City of Amsterdam.

The World Press Photo governing board consists of members with a wide-ranging interest in press photography. The international dimension is enhanced by a consultative body, the International Advisory Board, which comprises experts from the world of press photography including former jury members. World Press Photo committees are active in France, the United Kingdom and the United States.

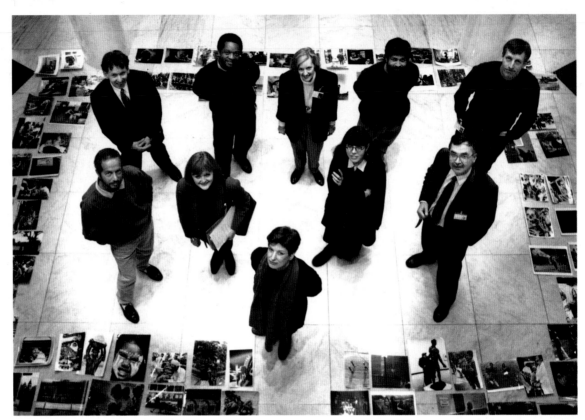

This year's jury.
From left to right:
Diego Goldberg, Argentina
Adriaan Monshouwer (secretary)
Elisabeth Biondi, Germany
Alexander Joe, Kenya
Sylvie Rebbot, France (chair)
Michele Stephenson, USA
Giovanna Calvenzi, Italy
Shahidul Alam, Bangladesh
Lev Sherstennikov, Russia
Bert Verhoeff, the Netherlands
Photo: Capital Press

FOREWORD

The prizewinning pictures of World Press Photo '94 were selected by a jury of nine members from four continents, a mix of photographers and picture editors with different backgrounds, all of them dedicated to their profession and committed to making the best selection from the 22,775 pictures, submitted by 2,429 photographers from 93 countries. More entries than last year, again – a regular pattern, attesting to the keen and increasing interest in the World Press Photo Foundation.

The jury's task was immense. For a week, the judging panel confronted the whole range of events that marked 1993, captured on film both in faraway places and much closer to home.

This book will be a testimony of all this work, featuring the results of the 37th contest. The photographs published here are a tangible witness of all our emotions during the judging, of our horror of the tragedies, of our tender feelings during lighter moments, of our laughter and surprise. The emotions we felt are also reflected in the book – and the parallel exhibition, which will be staged in many countries. It will be up to the viewers to appreciate the task of the photographers, who show us the world in the belief that they can help us understand it better.

Beyond the quality of their photography, we are witness to the photographers' direct involvement both with world events and with the people who, willingly or unwillingly, appear in their pictures. Through two-dimensional photographs, photojournalists bring us the lives of people from the moment they are born; their times of hardship, their achievements and their daily chores. When awarding prizes to photographers for their talent, we must never forget the people they picture.

The World Press Photo of the Year 1993 takes me back to a well-known picture taken by Robert Capa in a Haifa suburb in 1950: a little girl is crying in front of a tent in a camp for displaced persons – an icon of suffering. The photograph of the children of Gaza, taken 43 years later, also tells of suffering. But something has changed: the children are no longer just victims, they have become actors. The violence around them has seeped into them. They replay that violence, and beyond their game is a true participation in the adult world around them.

Some of these children do indeed take up weapons to fight in the Intifada. As such they are victims in more than one way, in a world which holds no promise for them.

The line between playing games and fighting a war has become blurred. Happily, in the Middle East there is now the beginning of a solution. Let's hope these children will live to see it come to fruition.

In November 1989 the United Nations adopted a convention on the rights of the child, which was signed by 135 countries. Its threefold goal is known as the three P's: Provision, Participation and Protection – the latter stands for children's right to be protected from harmful acts and practices. Despite this, one sometimes gets the impression that the world has forgotten that each child is special, and that in them we sow the seeds of tomorrow's world.

It is not World Press Photo's place to provide answers, only to ask questions through the pictures selected for awards. The interpretation of those pictures must be left up to the public.

SYLVIE REBBOT
Chair of the 1994 Jury
Picture Editor of Geo France
Paris

WORLD PRESS PHOTO OF THE YEAR

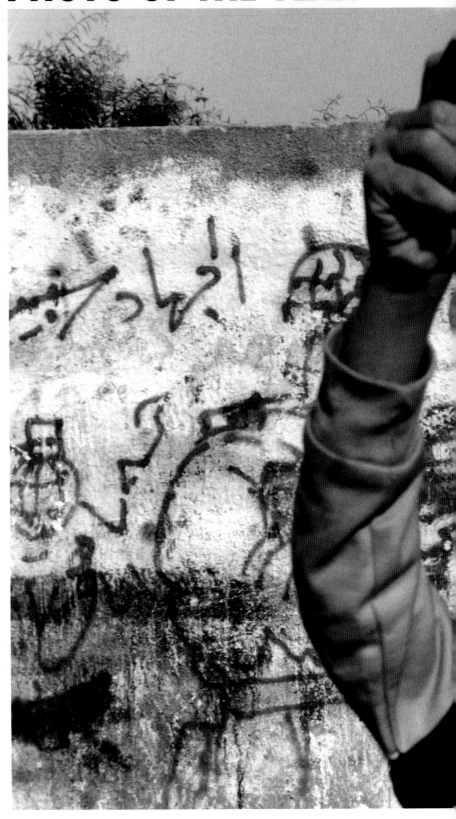

LARRY TOWELL
Canada,
Magnum Photos,
USA

**WORLD PRESS
PHOTO
OF THE YEAR**

9401

9401
Children of the Intifada. In the occupied Gaza Strip boys raise toy guns in a gesture of defiance. The Palestinian uprising, which started in December 1987, strengthened the Arab population in their determination to fight the occupying force. The picture was taken in March as part of a reportage spanning nine months.

In March Israel closed its border with Gaza, causing a massive rise in unemployment. With more than 800,000 people contained in the Israeli-patrolled, eight-kilometer-wide strip of land, bloodshed increased sharply. The peace agreement signed in Washington on September 13 promised limited autonomy for the Gaza Strip and a withdrawal of the Israeli army.

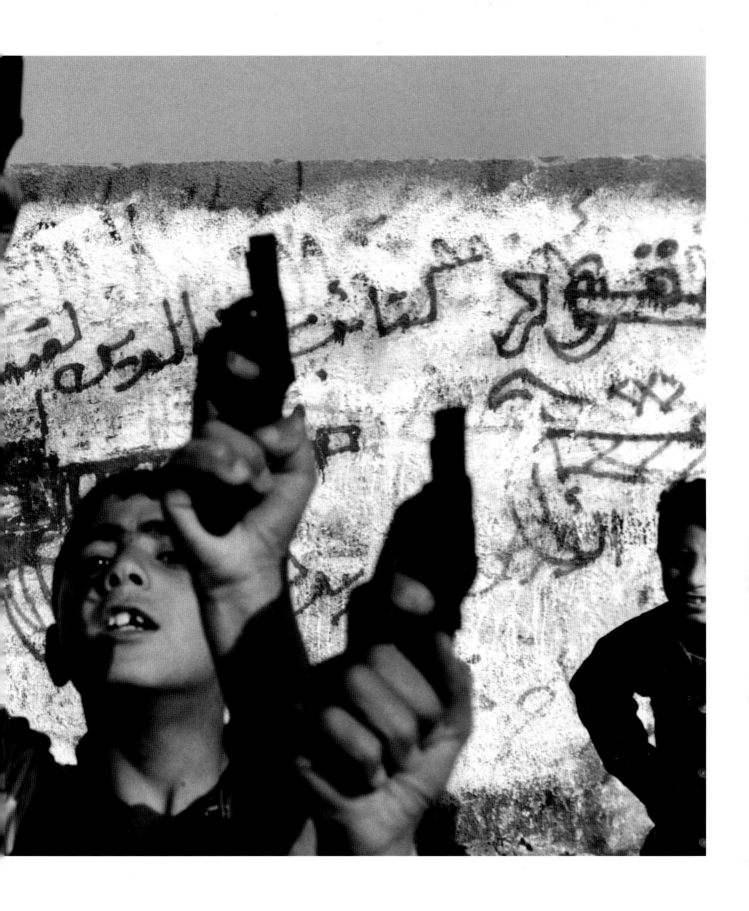

Larry Towell (40), a Canadian citizen, studied visual arts in Toronto. From 1979 to 1989 he taught folk music to make a living. His associate membership of Magnum Photos was converted to full member status in 1993. In 1994 a photo book entitled *Gaza* will bring the number of his books (of poetry, verbal testimonies and photography) to six. Towell's work has been published in magazines worldwide. At his home in rural Ontario, he combines photography with writing poetry and sharecropping.

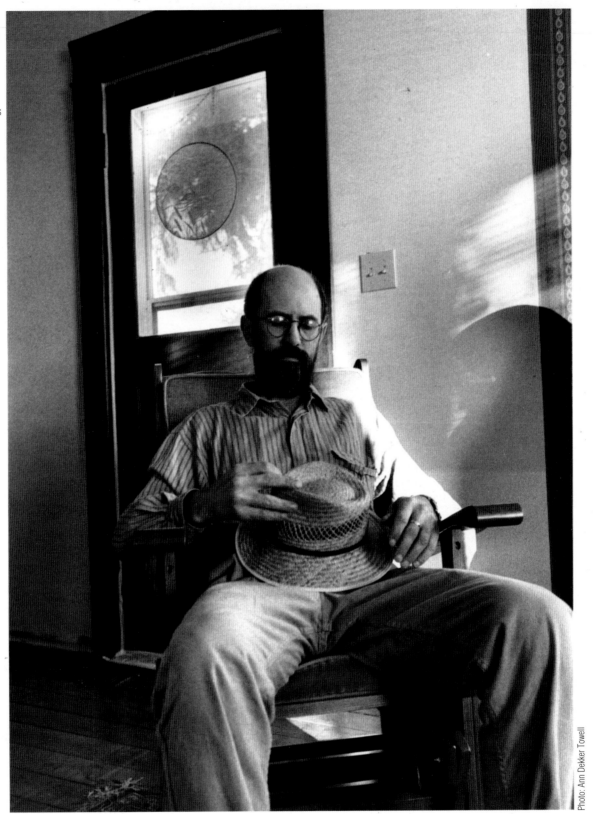

Photo: Ann Dekker Towell

LARRY TOWELL WAS INTERVIEWED SHORTLY AFTER HE LEARNT THAT HE HAD WON THE WORLD PRESS PHOTO PREMIER AWARD. SOME EXCERPTS.

How did you progress from the visual arts to photography?
I studied visual arts, the study of symbols. After graduating, I tried to make a living as a poet and then as a songwriter/performer, but I couldn't get over my stage fright. I then discovered the world through the lens of a camera. As a photographer, I could be both a witness and storyteller.
We don't often think about it, but there is a symbolic approach and a conceptual aspect to photojournalism that is common to the recording of history. A photo-story can be lyrical as well as linear, and in some cases the lyrical approach is more true to the subject matter. A poem, for example, is literature with the water squeezed out of it. And good literature is journalism that doesn't grow old. I think there is an important relationship between these disciplines.

How would you describe your photography?
Photography is just a natural expression of one's life. I'm a rural person, so I photograph the need for land. I photograph peasant culture and peasant rebellion, the rebellion of farmers. I'm a dramatist, so I'm more interested in how people think and in what they feel than in the controversy around them. People in pictures cannot lie about how they look and about what they are going through.
I photographed in Central America because I'm interested in organizations and their struggle against unpopular governments. I believe in the power of individuals and their alliances. We don't give enough attention to them because it is hard to afford the time. I've been photographing Mexican Mennonite migrant workers because they are a symbol of growing landlessness due to the effects of the globalization of world trade. I also like those people a lot. Robert Capa reminded us to like people and to let them know it. That's not a bad excuse for taking pictures.
Violence is a strong symbol for photojournalists, and a very important one. But it's not the *most* important one, because society has learned to disassociate itself from the victims. Society cannot turn its head away from daily life pictures. Novelists learned that a long time ago.

What is the place in your photography of hard news?
What is hard news? There are photographers who work for the wire services very well, much better

than I could, so I leave it to them. My photography might translate into news, but I'm more interested in storytelling. I don't compete with television, which throws spotlights rather than illuminating the environment. Before TV, as I understand it, photographers used to get long-term assignments. Now we're expected to run behind TV cameras and copy sound bites rather than do personal photojournalism.

Do you allow yourself to become emotionally involved?
If I'm supposed to like people, of course. In the 1990's over 90% of war casualties have been civilian. Most tragedies involve women and children, and most photographs in a positive, cultural context involve families. Of course I become emotionally involved. If I couldn't become involved, I might as well sell life insurance ads to the magazines.

Do you work only on long-term projects?
Inasmuch as the things I work on are interrelated. I don't travel as much as other photographers do, because I have a young family. I try to work methodically and not just produce pictures with no beginning and no end.

Where do you think photojournalism is going?
Downhill. I can't speak about the European market, because I don't know it very well, but in the US, it's dismal. Magazines, our traditional venue, are less committed to supporting photographers than ever before, which means we must find more meaningful venues - and I think they're out there. Magazines have shifted from the broader concepts embodied in their names, like *Life* Magazine, to the narrower one of *People* Magazine, to the even more introverted one of *Us* Magazine, to the narrowest concept of *Self* Magazine. This is our reality. I'm not picking on these magazines, but their names are a truism.
Photographs are not just a commodity - like a magazine or one's morning cup of coffee - any more than the people in the photos, or the people who picked the coffee beans are. Editors are very nervous about publishing serious stories when they are really only interested in selling underarm deodorant for their sponsors, or coffee. 'Revolutionary' has become an adjective for computer software, and 'peace' is owning a villa in Mexico. However, photojournalism has its tremendous rewards and it's wonderful work. In what other work can you wander aimlessly with a camera around your neck, armed only with your personal interest and your eyes?